This is
Matisse

LAURENCE KING

Published in 2015 by
Laurence King Publishing
361–373 City Road
London EC1V 1LR
United Kingdom
T +44 20 7841 6900
F +44 20 7841 6910
enquiries@laurenceking.com
www.laurenceking.com

ISBN: 978 1 78067 479 7

Series editor: Catherine Ingram

Printed in China

This is Matisse

CATHERINE INGRAM

Illustrations by AGNÈS DECOURCHELLE

LAURENCE KING PUBLISHING

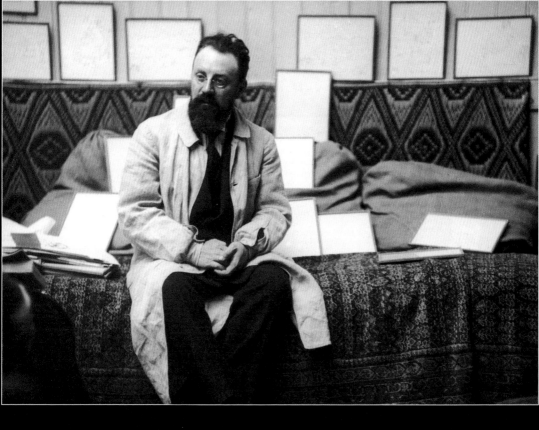

Henri Matisse in his studio
at Issy-les-Moulineaux
Alvin Langdon Coburn, May 1913

Henri Matisse dreamed of 'an art of balance, of purity and serenity… something like a good armchair which provides relaxation'.

In this photo of Matisse's family living room, we glimpse the complexity of the 'armchair artist'. Sitting on a sofa decorated with exquisite fabrics, his work arranged around him, Matisse's relaxation is intense. He plays with his hands, stares ahead, absorbed in his thoughts. The rigorously ordered environment is matched by his formal dress; the smart suit, tie and white coat are more the attire of a professor or a scientist than an Expressionist artist.

Through the turbulent first half of the twentieth century, and what Matisse called 'a collective sickness of the heart', his career was a painstaking attempt to find order in the midst of chaos and misery, and affirm the richness and beauty of life. To quote the artist: 'Without voluptuous pleasure, nothing exists.'

Matisse experienced life intensely, noticing things that are ordinarily missed, whether that was the sumptuous vanilla light of Tahiti or the curving movement of a garden snail unfolding from its shell. His paintings are indeed 'images of intensified life'. A sensuous overload, the vibrant colours refresh, while a powerful, ritualistic energy is unleashed. Figures dance nude. Swimmers leap. Birds soar into the air. And every element is brought into harmony.

'The root presupposes everything else'
Henri Matisse

Matisse said that for the first 20 years of his life he felt like he was imprisoned. He was born in the bleak flatlands of northeastern France. Matisse curator John Elderfield evokes a leaden atmosphere of 'grey skies' and 'villages of dull brick houses'. Frontier territory, the area had always been vulnerable to attack. In 1871, when Matisse was a baby, the Prussians invaded. Later, the horrendous reality of World War I trench warfare would unfold on the same flat borderlands.

Matisse's father set up a seed shop in Bohain-en-Vermandois, and while Matisse was growing up the artisan village was transformed by rapid industrialization. The new textile and sugar beet factories polluted the village with their waste – colour

dye leaked from the textile factories, and in winter the stench of rotting beets filled the air. As intensive farming took hold, the ancient forest was stripped out, and the pleasure and vitality of a bio-diverse environment was lost to the dull monotony of mud fields and sugar beets in regular rows. Matisse recounted, 'Where I come from, if there is a tree in the way, they root it out because it puts four beets in the shade.' Matisse sought out the long grass beyond the fields, where he enjoyed the birdsong, and he played on the Old Blasted Oak Tree, the village landmark.

Visitors to the village unveiled colourful worlds. Matisse dreamed of running away with the circus. Then there was the travelling hypnotist, who hypnotized the teenage Matisse, making him believe that the rug he was standing on was an exquisite field of flowers. The florid vision anticipates his aesthetic.

The village seed store

Matisse's father Émile Hippolyte opened his seed store in 1870 and, profiting from the expansion in commercial farming, it became a thriving wholesale business. The family lived above the shop and the children were expected to help; there were sacks to carry, seeds to be weighed, and the shop had to be cleaned and swept.

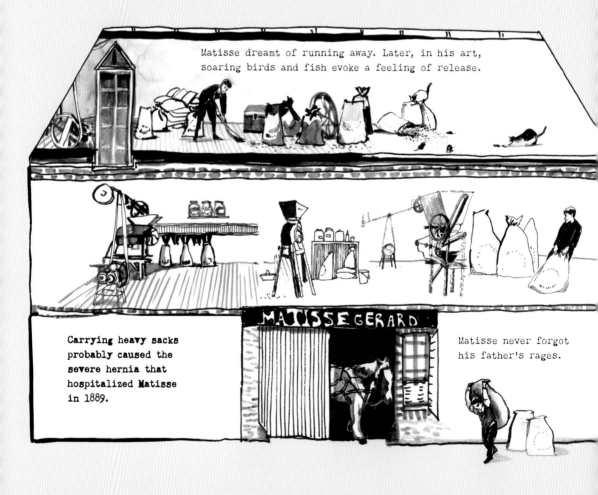

Matisse dreamt of running away. Later, in his art, soaring birds and fish evoke a feeling of release.

Carrying heavy sacks probably caused the severe hernia that hospitalized Matisse in 1889.

Matisse never forgot his father's rages.

Although the family business protected Henri and his younger brother from the grim reality of the village factories, Émile could be pretty fierce, shouting after his sons to work harder and faster. Matisse cocooned himself in his imaginative world. There were items on sale that probably captivated him too, like the goldfish and exotic birds, which would later feature in his art as motifs.

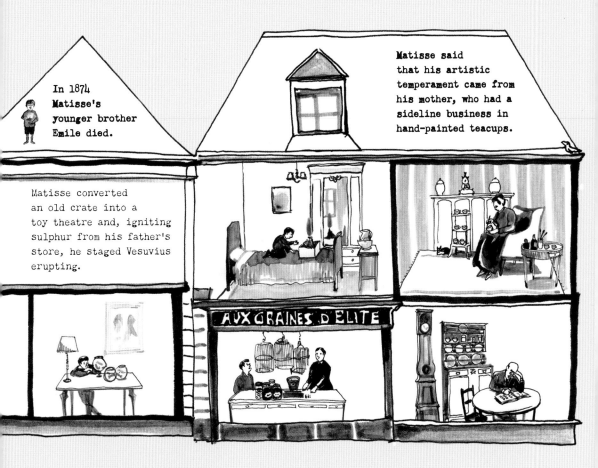

In 1874 Matisse's younger brother Emile died.

Matisse said that his artistic temperament came from his mother, who had a sideline business in hand-painted teacups.

Matisse converted an old crate into a toy theatre and, igniting sulphur from his father's store, he staged Vesuvius erupting.

AUX GRAINES D'ELITE

'All you need is daring': The street art of Bohain

Matisse's artistic career was very much rooted in Bohain's artisan culture. Without art galleries or museums, textiles were the visual currency. Matisse's family had been weavers for generations and, to quote Matisse biographer Hilary Spurling, 'textiles were in his blood'. Combining traditional craftsmanship and cutting-edge design, Bohain textiles were known throughout Europe, and were used by top Paris fashion houses such as Chanel well into the twentieth century.

Matisse's vision for art was essentially 'decorative'. Many regard decoration as a decadent artform, but Matisse had an attitude far more in keeping with that of the late twentieth century Pop artists – appropriating everyday objects and making art out of them, or finding it in them. In Bohain, textiles were part of a lively street culture; in the summer months handweavers worked on their doorsteps, artisans shared ideas, and the looms would spill exquisite woven fields of colour into the street. To Matisse – a sensitive child – this must have seemed more vital and alive than anything else around him, certainly more vibrant than the muddy palette of Bohain's landscape.

Village *sot*

Matisse liked the busy activity of street life, and would entertain friends with his brilliant mimicry, aping the traits of passers-by. When Matisse became an artist, the Bohain people thought his paintings talentless, clumsy images that failed to convey reality. They called him the village *sot* (fool). In many ways Matisse was the archetypal fool: the sensitive but wise outsider. His circus antics have a peculiar relevance to his art: following the method of a mimic, the painter would identify so strongly with his subject that he inhabited it. In his own words: 'When you draw a tree, you must feel yourself gradually growing with it.'

The shadows of the North propelled Matisse; like a buried seed, he would emerge and seek the light. The railway had reached Bohain in 1855, giving a ready escape route to life beyond the village.

New revelations

Finally accepting his eldest son's disinterest in the family business, Émile persuaded Matisse to study law; Matisse passed the exams, but found the work dull. The gift of a paint set was a revelation: 'From the moment I held the box of colours in my hands, I knew this was my life. I threw myself into it like a beast that plunges towards the thing it loves.' Much to his father's disappointment Matisse decided to study art in Paris. The feeling of having failed his father would always resonate for Matisse.

After an abortive relationship with Camille Joblaud, with whom he fathered a child, Marguerite, in 1898 Matisse met Amélie Parayre. He was enchanted by her 'mass of black hair which she put up in a charming style, especially at the nape of the neck. She had lovely breasts and very beautiful shoulders. She gave the impression, in spite of the fact that she was timid and reserved, of being a person of great goodness, power and sweetness.' Matisse warned his future wife that though he loved her very much he would always love painting more. The rather unromantic proposition worked for Amélie. Dedicated to Matisse, she adopted Marguerite, ran the house and her hat business, and in the night she would read aloud to her troubled husband when he couldn't sleep.

At their wedding, Amélie wore a couture dress gifted by socialite Thérèse Humbert, for whom Amélie's parents had worked for years. Not long after the wedding, Thérèse Humbert and her husband Frédéric were revealed to be perpetrators of a massive fraud. Amélie's parents were initially implicated in the case and her father was imprisoned. Though ultimately cleared of all involvement, the family felt shamed. This might explain why Amélie from around this time insisted Matisse wear a suit, where before he 'used to dress as carelessly as Picasso'. The village *sot* was given a respectable skin.

The collector emerges

The couple started their honeymoon in London because Matisse wanted to see the Turner paintings at the National Gallery. He was struck by their incredible use of light: 'Turner lived in a cellar. Once a week he had the shutters suddenly flung open, and then what incandescence! What dazzlement!' Continuing their honeymoon in Corsica, Matisse experienced this dazzlement for himself. Left hating the bleak northern skies of his childhood, the savage tenor of Corsica's bright sunlight would reverberate in his paintings of the Fauve period (1904–1908).

In Paris, Matisse was showing signs of becoming an obsessive collector. He bought a very expensive blue morpho butterfly, saying 'the blue, but such a blue. It pierced my heart'. The colour of the butterfly reminded him of the blue sulphur flame that he had burnt in his little toy museum. A year later he hankered after Cézanne's *Three Bathers*. This time Amélie pawned an emerald ring to raise the first instalment. Matisse said that the painting 'sustained me morally in the critical moments of my venture as an artist'. The ring was lost, as Matisse returned too late to redeem it from the shop.

One can sense Cézanne's appeal for the artist with 'textiles in his blood'. The painting has the texture of woven fabric; the groups of hatched, parallel strokes, like stitch-work, form colour patches that collectively build up the picture. And, like textiles, the background 'knits' together in a tight unity. Matisse would seek this decorative rigour in his own paintings. In *Luxury, Calm and Pleasure* he samples more directly from Cézanne's painting.

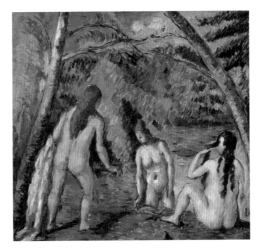

Paul Cézanne

Three Bathers (Trois baigneuses)
1879-82, oil on canvas
53 x 55 cm (20⅞ x 21⅝ in)
Musée du Petit Palais, Paris.

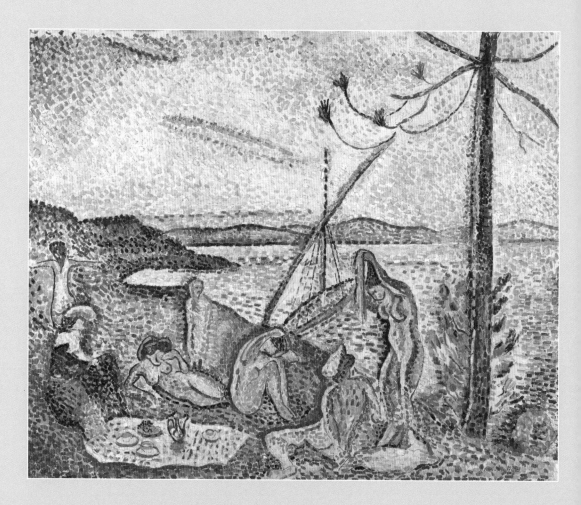

Luxury, Calm and Pleasure
(*Luxe, calme et volupté*)
Henri Matisse, 1904

Oil on canvas
98 × 118 cm (38½ × 46½ in)
Musée d'Orsay, Paris

Luxury, Calm and Pleasure, 1904–1905

At the end of his life Matisse would reflect that 'the artist has but one idea'. He is born with it and spends a lifetime developing it and making it breathe.' Matisse's idea is expressed in *Luxury, Calm and Pleasure*: a feeling of sensuous harmony. The far-left nude stretches out her arms, and receives the warmth of the sun. She conveys a feline sense of physically enjoying her movement. All his life Matisse would chase after sensual pleasure.

Really it is not until the very end of his career that Matisse's idea comes to full fruition. In *Luxury, Calm and Pleasure*, the illusion of sensual pleasure collapses. The inclusion of a fully dressed Madame Matisse among the voluptuous nudes is awkward. We also find Matisse's son Jean wrapped in a towel looking rather like a mummified carcass. We fluctuate between two very different worlds, a bourgeois picnic scene with teacups laid, and an Arcadian paradise. Artistic influences clash. Matisse borrows from Cézanne, reproducing the subject of bathers in a landscape and replicating compositional features, like the framing vertical tree. However, the shockingly bright colour betrays Cézanne's soft harmony, and owes more to the Neo-Impressionist Paul Signac.

The previous summer Matisse had visited Signac, who had developed his own colourful palette based on the science of Michel-Eugène Chevreul. Working in a dye factory, Chevreul had observed how the intensity of a primary colour could be enhanced if it was partnered with its 'complementary' colour. Chevreul visualized his theory in a colour wheel – complementary colours sit directly opposite each other. *Luxury, Calm and Pleasure* uses complementary colours (for example, the red of the beach set against the green towel) to convey the dazzling Mediterranean light.

Circle demonstrating colour differences and contrasts, from *Expose d'un Moyen de definir et de nommer les couleurs*, by Eugene Chevreul, published in Paris by Firmin Didot in 1861.

The wild beast

For many years people had gathered at the annual Salon d'Automne to laugh at Matisse paintings. Art critic Louis Vauxcelles called Matisse and his fellow French Expressionists 'the Fauves' (in English, 'wild beasts'). Humiliated, the village *sot* told his wife to stay away. *The Green Line* was exhibited at the 1905 Salon. It remains a shocking portrait, an unadorned, almost brutal image of Matisse's young wife. The turquoise-green line that runs the length of Amélie's nose splits her face into two: the yellow-green half vibrates against the cherry red side. The flat modelling of the face, the high eyebrows and black circular pupils may well reflect the influence of African carvings, which Matisse had started collecting.

Art historians often envisage a battle between abstraction and naturalism, where the abstract forms obscure the sitter's identity. However, in Matisse's hands, form is revelatory. As a child, the local textiles appeared more vital, more alive than the muddy dreariness of the 'real' world. In 1908, Matisse published 'Notes of a Painter', in which he insists, 'Expression, for me, does not reside in passions glowing in a human face, or manifested by violent movement. The entire arrangement of my picture is expressive'.

The bold planes of vibrant colour, the black helmet of hair, and reduced features confer majesty to Amélie. A formidable force, a modern Athena, we face the woman who, in her own words, was 'in her element when the house burns down'.

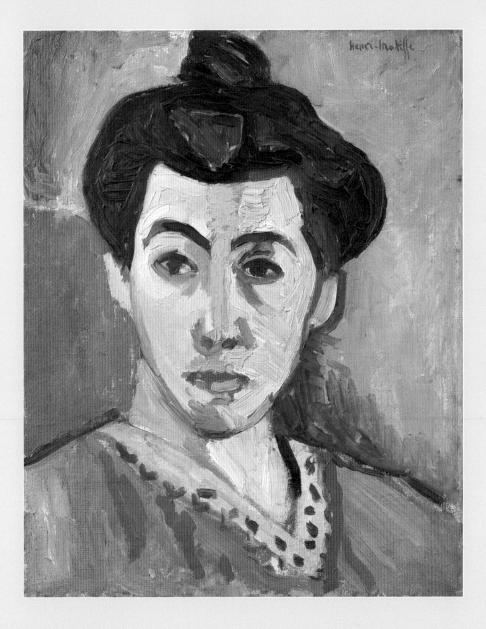

Portrait of Mme Matisse: The Green Line
(*Portrait de Mme Matisse: La raie verte*)
Henri Matisse, 1905

Oil on canvas
40.5 × 32.5 cm (16 × 12¾ in)
National Gallery of Denmark, Copenhagen
Gift Ingeniør J Rump og hustrus Fund – 1936

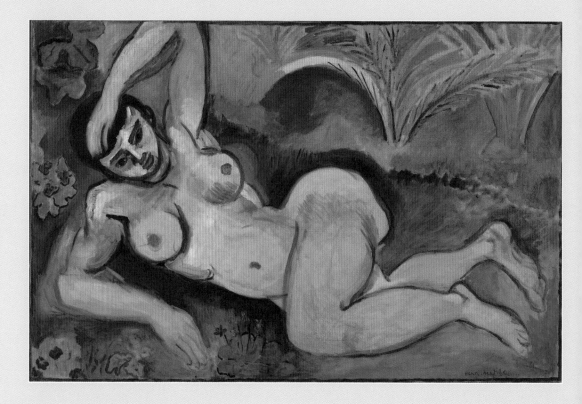

Blue Nude: Memory of Biskra
(Nu bleu: Souvenir de Biskra)
Henri Matisse, 1907

Oil on canvas, 92.1 x 140.4 cm (36¼ x 55¼ in)
The Baltimore Museum of Art, Maryland
The Cone Collection

The 'ugly nude woman', Louis Vauxcelles, 1907

In search of that intense southern light, Matisse set off to Biskra in French Algeria in 1907. On arrival he 'found it slightly insipid'. The desert had the same boundless monotony of the flatland of northeastern France, and the 'blinding sun' bleached out every colour. However, the local crafts caught his attention, and he brought a few souvenirs home.

Blue Nude has the subtitle *Memory of Biskra*, though it does not immediately feel North African; the nude is Western looking, and holds a Classical pose. Among Matisse's Algerian souvenirs were some rugs. The composition of *Blue Nude* – with its thick border of patterned vegetation framing a dark, inner core – has the ghostly form of an Algerian rug. In the painting, the border has a flattening effect, and pushes the nude forward, where she appears 'pressed against a window'. Held there, we scrutinize her. Applying the logic of Paul Cézanne's multiple viewpoints to the human figure, Matisse gives us a walk-round, with a full frontal view of the torso and breasts and a high viewpoint on the buttocks and thighs. The confrontational gaze is uncharacteristic of Matisse and feels more Picasso-like. Indeed, Picasso would respond to this work with the far more aggressive examination of *Desmoiselles D'Avignon*.

What is very Matisse-like about the painting is its vitality. Matisse awakens the academic tradition of passive, immobile nudes. Although lying down, the blue nude emanates energy, particularly around the sexual organs, where a radiating blue – perhaps reminiscent of that blue sulphur flame – silhouettes her breasts and her bottom. It is as though her charge of energy flows into the natural world and blossoms in the arching ferns.

The glowing colour behaves like radium, emanating energy from its atomic core. Four years earlier, Marie and Pierre Curie had been awarded a Nobel Prize for isolating radium. Unaware of the health hazards (Marie Curie kept a pile of glowing radium on her bedside table to light her room), the phosphorescent light caught the nation's imagination. It is very likely that the child chemist, who combusted chemicals in his father's seed factory, knew of this new energy.

A junkshop find

From the upper deck of a Parisian bus, Matisse spotted an old
piece of toile de Jouy fabric in a junkshop. Of unremarkable
pedigree, a copy of an original Jouy design, the fabric became
very important to Matisse. In recent years avant-garde artists
had been exploring decorative arts; in some of Van Gogh's
portraits, for example, the wallpaper takes on a narrative role,
with lush floral designs often symbolizing the sitter's exuberant
personality. Matisse's piece of toile de Jouy fabric, with its
abundant flowering baskets and wielding arabesques,
has a similar vitality.

The first time the fabric appears in a painting, it plays a modest
role as a tablecloth in a simple interior scene. In *Still Life with Blue
Tablecloth* Matisse extends the cloth beyond the table, and also
uses it as a backdrop. The effect is dramatic. The exaggerated
arabesques seem to grow upwards like virulent vines. A botanical
force is unleashed. The painting marks a turning point for Matisse
as he moves into his 'decorative phase'. The fabric defines an all-
over patterned field, in which fluid arabesques release their energy.
But there is a tension – the solid material objects (the coffee pot,
vase and fruit bowl) contradict the dynamic decorative impulse.
Two orders sit in an unhappy marriage.

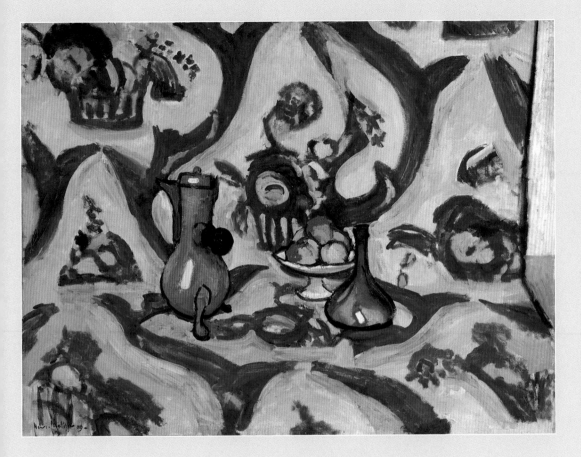

Still Life with Blue Tablecloth
(*Nature morte avec camaïeu bleu*)
Henri Matisse, 1909
Oil on canvas, 88.5 x 116 cm (34⅝ x 45⅔ in)
The State Hermitage Museum, St Petersburg

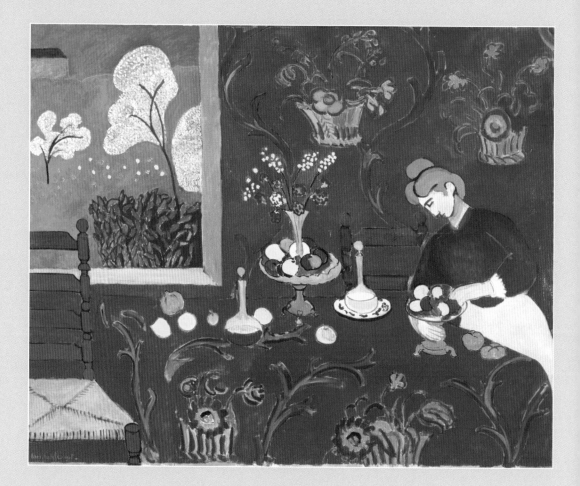

Red Room (Harmony in Red)
(*La chambre rouge; La desserte – harmonie rouge*)
Henri Matisse, 1908

Oil on canvas, 180 × 221 cm (70⅞ x 86⅝ in)
The State Hermitage Museum, St Petersburg

A philosophical harmony

At the time Matisse was working on *Still Life with Blue Tablecloth*, philosopher Henri Bergson was at the height of his popularity and the fashionable stormed his lectures at the Collège de France. Bergsonian vision is joyful. A sensualist, Bergson challenged the tradition of Western philosophy; in particular he rejected the idea of a material world with solid things set in space, instead celebrating a dynamic sense of being, a world in motion. Focusing first on the structure of our consciousness, Bergson pointed to the internal flow of time (in French, *durée*), where 'memory… prolongs the past into the present'. In 1907 Bergson moved on to his more fantastical concept of the *élan vital* – a surging, botanical life force.

Red Room (Harmony in Red) 1909

Matisse's manifesto 'Notes of a Painter' (1908) has a Bergsonian flavour, and explicitly references Bergson's *durée*. In 1909 Matisse became friends with the eccentric Bergsonian aesthetician, Matthew Prichard.

Bergson's vitalist philosophy supports Matisse's decorative vision, which he advances in *Red Room (Harmony in Red)*. Using the same piece of toile de Jouy fabric, but this time through an entire interior, the fabric takes over completely. The saturated red dissolves the material world (which Bergson sees as superficial), although it is still present; the table is defined in a whisper of a line, other things have more substance, like the chair or the fruit bowl. Unlike the earlier *Blue Tablecloth*, solid objects are incorporated into this decorative impulse: the fruit scattered on the table seems to have fallen off the branches on the fabric, while the stems of flowers sprouting from the vase briefly define the arabesque branches that rise up the wall. As the rhythms coincide, the energy builds and the wielding botanical forms unfurl.

A network was slowly gathering around Matisse. While the Americans Michael and Sarah Stein had been collecting his work for a few years, a solid new patron also emerged: Sergei Shchukin. Head of his family textile business, Shchukin was peculiarly receptive to Matisse's decorative vision. The new financial security liberated Matisse: after setting his family up in a new house in the suburbs, he would spend the next few years travelling.

Issy-les-Moulineaux

In the autumn of 1909, Matisse moved his family to Issy-les-Moulineaux, a suburb of Paris. Very quickly a tidy discipline overtook their life. The decorative order of Red Room (*Harmony in Red*) anticipates the set-up, which was like a mini Versailles, a beautiful house with exquisite interiors, and a formal garden that Matisse called his 'petit Luxembourg'. Matisse's father visited his son at his home and Matisse gave his father a tour of the garden, showing off Amélie's newly planted beds of flowers. Typically, Émile Matisse managed to convey a sense of disappointment. Matisse's own son Pierre describes the dynamic: 'My grandfather loved his son, and his son loved him, but they couldn't get through to one another. My father never talked about that, but I think that it made him very unhappy.'

'Why not grow something useful, like potatoes.'

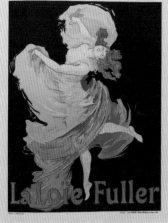

Poster advertising the Folies-Bergère
Jules Cheret 1893

Colour lithograph
123.2 x 87.6 cm (48½ x 34½ in)
St Bride Printing Library, London

Dance

In a newly built studio at the bottom of his garden, Matisse started work on a monumental painting, *Dance*. It remains a shocking piece. Five naked, electric-red dancers propel themselves forwards. For Marshall Berman, 'Clothes become an emblem of an old, illusory mode of life… and the act of taking one's clothes off becomes an act of spiritual liberation, of becoming real'. Matisse's dancers have a brutish 'realism', with their muscular physiques, red-raw flesh and breathless pace.

Modern science had unveiled a body never seen before. Contemporary dancer Loie Fuller was using cutting-edge lighting, mixing chemical gels to create spectacles of moving luminous colour. (She even contacted Marie Curie to ask if she could dance with radioactive radium.) Posters plastered around Paris foregrounded the dancer's explosive colour. Matisse references one of Fuller's dances in the title of one of his paintings. Mirroring Fuller's performances, *Dance* unites electrifying colour with powerful, ritualistic movement.

The painting has a startling immediacy. Where the legs of the foreground dancer and the head of another dancer are cut off by the picture frame, there's the suggestion that the figures extend beyond the frame into real space. Consequently, the spectator is included in their world. The incomplete circle invites us to take one of the dancers' hands and join the dance and propel the motion. The energy of the dance infuses us.

overleaf
Dance (La danse)
Henri Matisse, 1910

Oil on canvas, 260 x 391 cm (101⅜ x 153½ in)
The State Hermitage Museum, St Petersburg

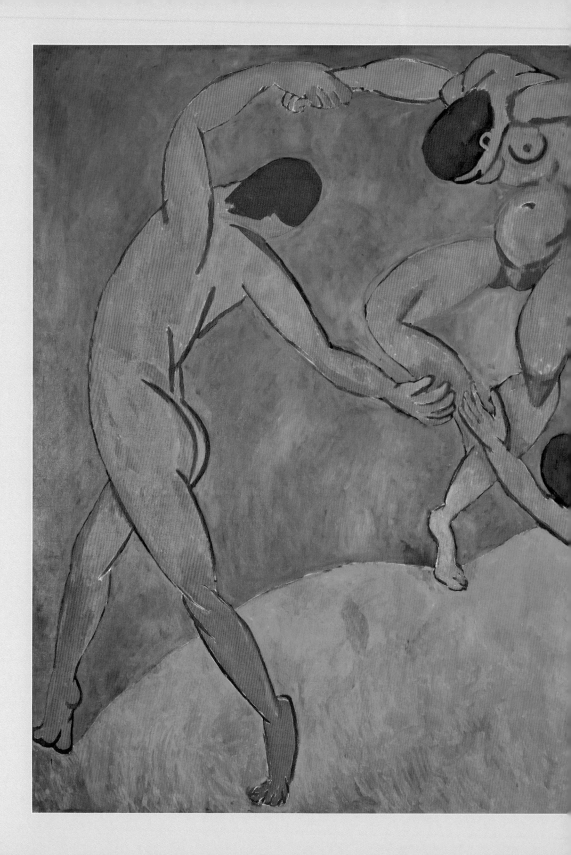

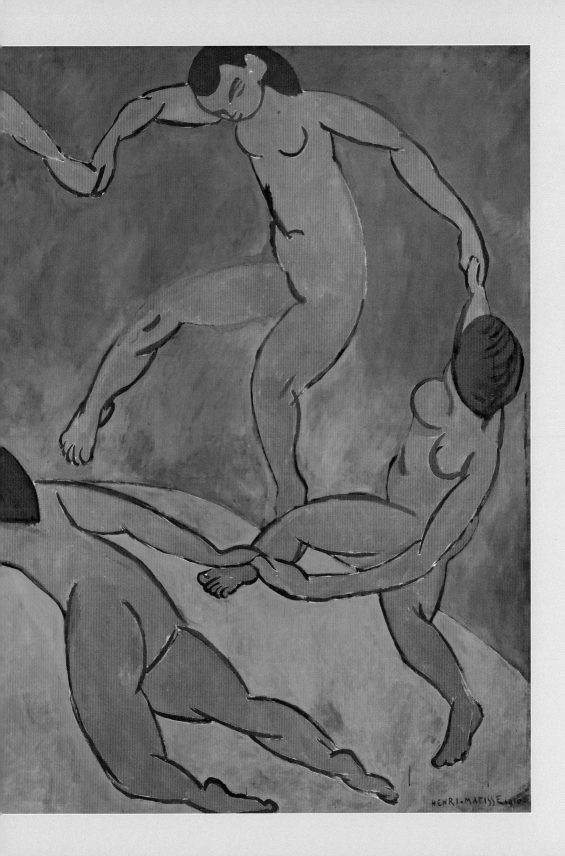

'I have to decorate a
staircase... I imagine
a visitor coming in from
the outside... one must
summon up energy, give
the feeling of lightness.
My first panel represents
dance, that whirling round
on top of the hill.

On the [next] floor one
is within the house; in
its silence I see a scene
of music with engrossed
participants.'

Henri Matisse

A modern impulse

Dance was part of a radical decorative scheme for Shchukin's home – a second painting with an identical colour scheme called *Music* hung beside it. Matisse envisaged a sort of architectural promenade, where his paintings responded to the building and mirrored the atmosphere. From the hall, the visitor could see *Dance*; Matisse's idea was that the painting's exuberant energy would propel the visitor upstairs. With *Music* only fully visible from the first floor, Matisse chose a scene of repose to punctuate the end of the journey upstairs, and the visitor's state of rest. The musical theme also visualized the music that played in the upstairs concert room.

The concept was modern. The first cinema halls were opening, and Matisse's scheme – the frieze-like paintings, and the development of a theme through successive screens – had a cinematic quality. Matthew Prichard didn't know Matisse when the artist started this project, yet the result came uncannily close to his notion of real art, where the spectator is immersed in a dynamic experience.

'And those who were seen dancing were thought to be insane by those who could not hear the music.' *Nietzsche*

Before *Dance* was shipped to Russia, it was exhibited at the Salon d'Automne. Sergei Shchukin, who was in Paris at the time, visited the Salon and saw the crowds mocking and laughing at the painting. He sent word to Matisse that he'd decided not to buy either *Dance* or *Music*, though he quickly reversed his decision. Matisse was being criticized from every angle: the English critic Roger Fry pompously compared the simplified forms to his daughter's scribbles, while the Paris avant-garde thought his art was too lush. Picasso and his circle snubbed Matisse when he visited one of their favourite Montmartre haunts, and Picasso followers scrawled graffiti warning 'Matisse induces madness' and 'Matisse is more dangerous than alcohol'.

Matisse complained to Gertrude Stein, 'Painting is so difficult for me. It is always a struggle'. Compelled to paint 'because one is so unhappy', he nevertheless felt exposed in the process. Matisse would find support from Matthew Prichard. In 1909 a friend had shown Prichard a sketch of Matisse's *Dance*. Thrilled by it, he appointed himself as a mentor to Matisse.

Intense theorizing

Matisse's new studio became a forum for 'intense theorizing'; sometimes there were as many as 20 people there. These sessions were led by Matthew Prichard. Based on Bergson's ideas, Prichard had developed a theory of art. His central thought was that art should be dynamic in nature. He criticized the static nature of Western art, and heralded instead the rich decorative schemes of Islamic and Byzantine art. According to the poet TS Eliot, Prichard was highly persuasive. Prichard spoke extensively to Matisse about the relevance of Byzantine tradition and this may well have prompted Matisse's extended 'Grand Tour' of Byzantine and Islamic culture.

'real art is... a function, an activity, a process'

The Orient has saved us…

Matisse spent almost three years travelling. In previous centuries a tour of Italy's collections, antiquities and ruins had been an integral part of an artist's training, however this 'grand tradition' had little relevance to Matisse, and his decorative vision for art. Instead he looked to Byzantine and Islamic art, and their fascination with surface and pattern.

Matisse set off first to Munich to see the 'Exhibition of Masterpieces of Mohammedan Art' in 1910. The poster – with its modern graphics – announced Islamic art as something relevant for contemporary society. Rejecting the exotic bazaar displays that had been popular for so long, the curators showed the works in crisp, minimal settings that foregrounded the artistic quality of these objects. The works themselves were extraordinarily beautiful.

Matthew Prichard was in Munich at the same time. He drew connections between Matisse's approach and the Oriental vision, insisting on the superiority of Islamic art over Western art:

> The error of exaggerating the importance of representation which distinguishes all European art except Byzantine was avoided in the Orient where, with a prescience of its impossibility and vulgarity, the authorities or tradition forbade its encouragement. In compensation, what carpets, what pottery, what crystals, what woodwork, what architecture…

One can imagine Matisse's excitement at the display of Islamic silks and Persian carpets. Some historians argue that Islamic art revolutionized his style. But in truth, Matisse was already on a trajectory; Islamic art was more of a catalyst. On 15 October Matisse heard that his father had died; he rushed home to Bohain for the funeral.

Spain

A couple of weeks after his father's funeral, Matisse received the news that Shchukin had finally decided not to buy *Dance* and *Music*. His patron's doubt coupled with his father's death toppled Matisse. Already exhausted, he was unable to sleep and started hallucinating. In this anxious state, he decided to take another trip, this time to Spain. At first he seemed better, but by the time of his arrival in Seville he was in a state of panic: 'My bed shook, and from my throat came a little high-pitched cry that I could not stop.' The local doctor diagnosed depression, and advised Matisse to keep a strict routine, which he did for the rest of his life.

'The Alhambra is a marvel. I felt an intense emotion here.'
Henri Matisse

Unquestionably, the climax of Matisse's Spanish trip was his visit to the Alhambra. Very much 'a 'marvel', the Alhambra defies logic. Situated on a mountainous peak in an area that experiences scorching heat, an oasis of greenery frames the delicate beauty of the Alhambra palaces.

The palace buildings shimmer. Meticulously orchestrated, the fabric of the architecture renders the weighty weightless. The long pool in the Court of the Myrtles reflects the building, framing it as a floating image on a translucent surface, while the exquisite patterning on the capitals of the load-bearing columns makes their massive load appear feather-light. The ephemeral beauty resonates with the Islamic conception of a fleeting world of appearance, where natural splendours – a morning dawn, an epic sunset – are insubstantial and momentary. When Matisse visited Morocco and Tahiti, he would be drawn to this transitory beauty in nature.

Matisse sent postcards of the Alhambra home. Typically throwaway items, they were obviously treasured by Matisse, as they remain in the family archive. His next paintings would have the graceful intricacy of the Alhambra's decoration. He would experience the Alhambra's magic – that feeling of feather-lightness – years later in the architecture of New York. And it would manifest in his own art, in his final monumental cut-outs.

Seville interior

After his visit to Granada, Matisse settled in Seville, where he painted two versions of Seville interior. Centre stage is a pomegranate rug that Matisse had picked up in Madrid. Typically, Matisse relishes the decorative pattern, the abundant fruiting branches of pomegranate against the rich Prussian blue. By having a 'close-up' on the textiles, he avoids the conflict of *Blue Tablecloth*, where the space is awkward and the illusion of a three-dimensional 'real' space is at odds with flat, decorative elements. In the Alhambra Matisse would have seen decoration playing a central role and this probably fuelled this confident expression. The decoration invades the picture plane and everything is more intense: the colours are zesty, and the arabesques pulsate with the energy of Pollock's drip paintings.

What is new for Matisse – and which points to his studies of Islamic decoration – is the variety of patterns at play, the flamingo fabric, pomegranate rug and opulent tablecloth. The collaging together of these different textiles may reflect the Alhambra interiors and their layers of contrasting patterns. One postcard that he had sent home details one of the Alhambra's richest decorative schemes, combining many different design elements.

Matisse had only meant to spend a month in Spain, but in the end he was away for two months. Miserable with her suburban life at Issy, Amélie sent her husband resentful postcards. With remarkable insensitivity, Matisse sent back a plan of action – a list of chores to occupy Amélie, which included making sure that the children rinsed their mouths with antiseptic wash. On 22 December he felt the need to write again, and this time he included her family: 'Dear father-in-law, dear sister-in-law, dear wife, I count on you to convince Amélie, who is absolutely furious with me, that I came here for the sole purpose of working…'

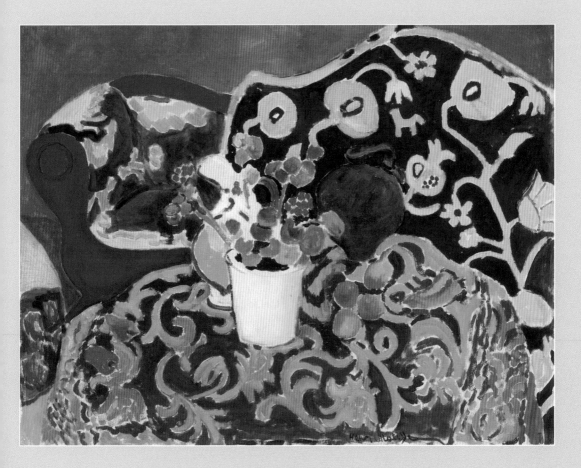

Seville Still Life
(*Nature morte Seville*)
Henri Matisse, 1910-11

Oil on canvas, 90 x 117 cm (35 ⅜ x 46 in)
The State Hermitage Museum, St Petersburg

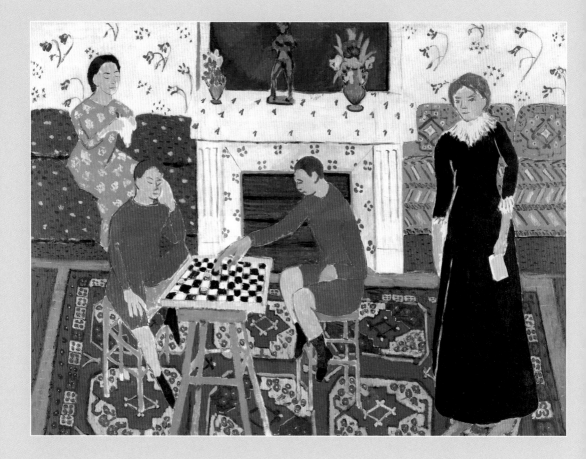

The Painter's Family
(*La famille du peintre*)
Henri Matisse, 1911

Oil on canvas, 143 x 194 cm (56¼ x 76⅜ in)
The State Hermitage Museum, St Petersburg

Tensions build

Matisse only brought home the two Seville still lifes from Spain. On his return to Issy, he then retreated to his studio and commenced a series of monumental paintings that the artist called the 'grand symphonic interiors'. *The Painter's Family* is one of them. Nearly 1.5 m (56 in) high and almost 2 m (76 in) across, Matisse takes delight in colour and pattern.

Again reflecting the textured layers of Islamic art, Matisse collages together different decorative elements; this time the mix is more eclectic. The French wallpaper has a spring-like delicacy, with its informal 'scatter' of wispy flowers, while the Oriental rug has a rich, geometric pattern. Everything is fastidiously balanced. For example, the aqua-green of the vases is repeated in his daughter Marguerite's shoes and then in the rug. As the identities of the Matisse family members are subsumed within the decorative order, tensions loom in this rather brittle domestic order. Perfectly upright, wearing the right costumes, the family perform for Matisse, but perhaps no longer so willingly. With disarming honesty, Matisse casts Amélie as a haughty lady of leisure, very different to the bold warrior that we met in *The Green Line*. The tidy order feels insufferable. Matisse would later comment, 'One can't live in a house too well kept… One has to go off into the jungle to find simpler ways which won't stifle the spirit'.

As a scurrilous counterpoint to this austere family portrait, Olga Meerson – one of Matisse's prize students – painted a very relaxed Matisse, lounging in his pyjamas. Olga was in love with Matisse, and to complicate matters she was addicted to morphine. The literature on Matisse tends to suggest obsessive love on Olga's part, but her portrait has a convincing intimacy.

Matisse and Picasso are often compared: while similarities are drawn between their artistic practises, their characters are usually posed as diametrically opposed, with Picasso playing the flamboyant womanizer and Matisse the family man. Matisse fostered the family man image, but it is somewhat disingenuous. He was often absent from family life, living abroad for extended periods when the children were growing up. Although Picasso and Matisse were very different men, both were preoccupied with their own desires. Essentially Matisse was a man of many skins – the cloak of respectability should not obscure his intense core, otherwise we risk nulling the charge of his art.

'Where I got the colour red – to be sure, I just don't know.'
Henri Matisse

Matisse's blood-red studio of 1911 dissolves the solid world; the ghostly clock, table, chair and chest of drawers are rendered with a thin, transparent line. In a playful symbol, rejecting analytical time, Matisse also removes the hands from the clock. This is a different order. Art has priority. A life-enhancing force, the artworks show off their bold colours and animated patterns, while the nudes reveal their sensuous form. In one painting, a swirling plant winds itself around a sculpture of a reclining nude, the suggestion being that they share a natural energy.

Ultimately the vitality of art is expressed in the curtain of blood red. When Abstract Expressionist Mark Rothko saw *Red Studio* at New York's Museum of Modern Art, he wept. Another person who understood the emotional intensity of Matisse's work was his patron Sergei Shchukin. Shchukin had experienced a terrible sequence of tragedies: his wife had died suddenly, and two of his sons and his brother had committed suicide. Matisse's art came to play a therapeutic role for him; indeed Matisse said that he had Shchukin in mind when he thought of art functioning as a good armchair. Shchukin would sit for hours in front of his Matisse paintings. He would collect 37 of his canvases. And, anticipating Mark Rothko's chapel, he made his home into a soothing temple of art.

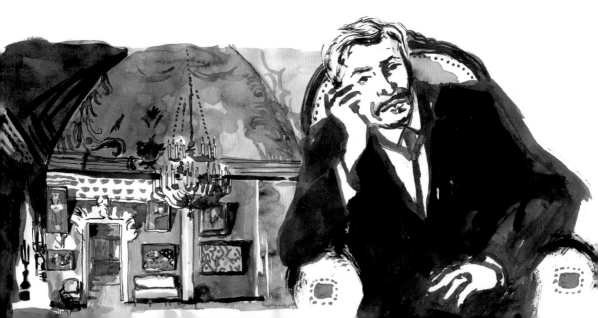

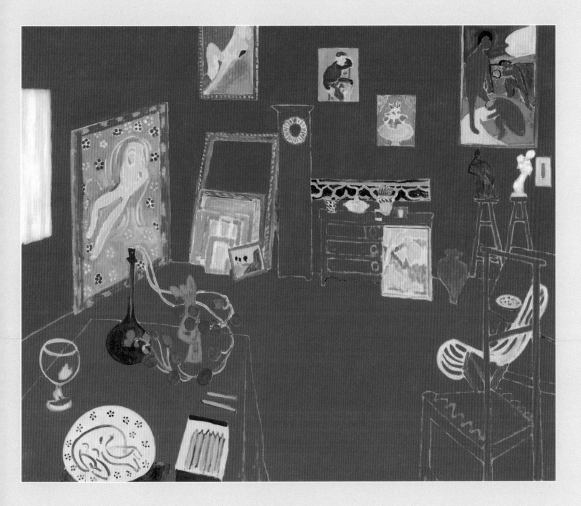

The Red Studio (L'atelier rouge)
Henri Matisse, 1911

Oil on canvas, 181 x 219.1 cm (71¼ x 86¼ in)
Museum of Modern Art, New York
Mrs. Simon Guggenheim Fund. Acc. n.: 8.1949

Autumn 1911, Russia

Matisse accepted Shchukin's invitation to view his work in situ, in Schchukin's palatial home in Moscow. Shchukin had been promoting Matisse's art in Russia for years. Matisse was treated like a celebrity – Shchukin had asked his friend, the art collector Ilya Ostroukhov, to act as Matisse's personal guide. Ostrouskhov organized a tour of the old cathedrals and museums, and showed Matisse his personal collection of Russian sacred art. The newspapers followed Matisse's visit. There was some bad press, and one critic felt his work was decadent and comparable to the decorative design of a necktie: the very same criticism would be levelled at Jackson Pollock 40 years later. But for the most part he was revered. He was taken to the Moscow Art Theatre, and he saw the *Queen of Spades* at Zimin's Opera, where Zimin met him for tea in the interval and – at Zimin's request – Matisse filled four pages of the visitors' book with colourful sketches of flowers. At the Society of Free Aesthetics Matisse was guest of honour and supposedly 'charmed everyone with his orange beard, smoothly parted coiffure, and pince-nez'.

Matisse felt a deep connection with the city. He told one reporter:

> Moscow has made an extraordinary impression on me. She has much of distinctive beauty. Your cathedrals are beautiful and majestic. They are monumental and have style. The Kremlin, certain corners of Moscow, the remains of your ancient art are of a rare beauty. I loved the ornaments of the Iversky chapel and the ancient icons.

Matisse appreciated the sincerity and immediacy of the art. The cathedrals have a human quality, like the iconic Cathedral of the Annunciation (which Matisse visited twice), with its chunky form and onion-shaped golden domes. And St Basil's too has its famous candy-coloured turrets. Matisse talked fondly of the playful cacophony of styles used in the Kremlin towers. For him:

> This is primitive art. This is authentic popular art. Here is the primary source of all artistic endeavour. The modern artist should derive his inspiration from these primitives.

'You surrender yourself that much better when you see your efforts confirmed by such an ancient tradition. It helps you jump over the ditch.'
Henri Matisse

What especially impressed Matisse were the old icons. After seeing Ilya Ostroukhov's exquisite collection, Matisse could not sleep all night, because of 'the acuity of the impression'. The icons – their flat design, vivid, pure colours and sinuous lines – confirmed Matisse's decorative vision. But they also seemed to reconnect him with the human figure; for despite insisting that 'the human figure… best permits me to express my almost religious awe towards life', the figure had become a ghostly presence in his art. While he was in Russia, Shchukin commissioned further canvases for his home. In this next series of paintings – painted in Morocco – Matisse would confer the local people of Morocco with the majesty of the Russian chapel's hieratic figures.

Our Lady of Vladimir has no background detail. Mirror flat, we meet the Virgin and her Child face to face. At the end of his life Matisse made his own image of the Virgin and Child for the chapel at Vence, which has the intimacy of the Vladimir icon. Matisse openly acknowledged the source of inspiration: 'I brought the heads closer together, the way they do in some Russian icons… There has to be more love.'

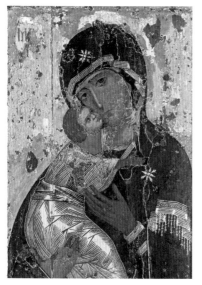

Our Lady of Vladimir (Eleousa)

Artist unknown,
Early 12th century,
Tempera on wood,
104 x 69 cm (41 x 27 in)
The State Tretyakov Gallery, Moscow

The retreat

Like the hanging of *Dance* and *Music* in Shchukin's house, in the Cathedral of the Assumption, painting and architecture (and during a service, music too) work together, creating an immersive experience for the spectator. After the exterior's sumptuous simplicity, one enters the building to be surrounded by the extraordinary iconostasis. A radiant glow emanates from these golden walls. Supposedly, in Moscow, Matisse was obsessing about the sun – perhaps the golden cathedral interior made him think of the light, and warmth, of the southern sun.

In Moscow, Matisse met up with Olga's sisters. Realizing that Olga was in a very fragile state, they decided the best thing was that Olga was admitted to a Swiss sanatorium. While Matisse was away, Olga had been goading Amélie with the deep connection she claimed to have with Matisse. Matisse vehemently denied that they were having an affair. However, Amélie intercepted a letter of Matisse's, which confirmed that at the very least her husband was aware that Olga was in love with him. She was furious. Back at their home in Issy, Matisse desperately tried to piece things together with his wife. Eventually, he convinced her to join him on his next journey to Morocco.

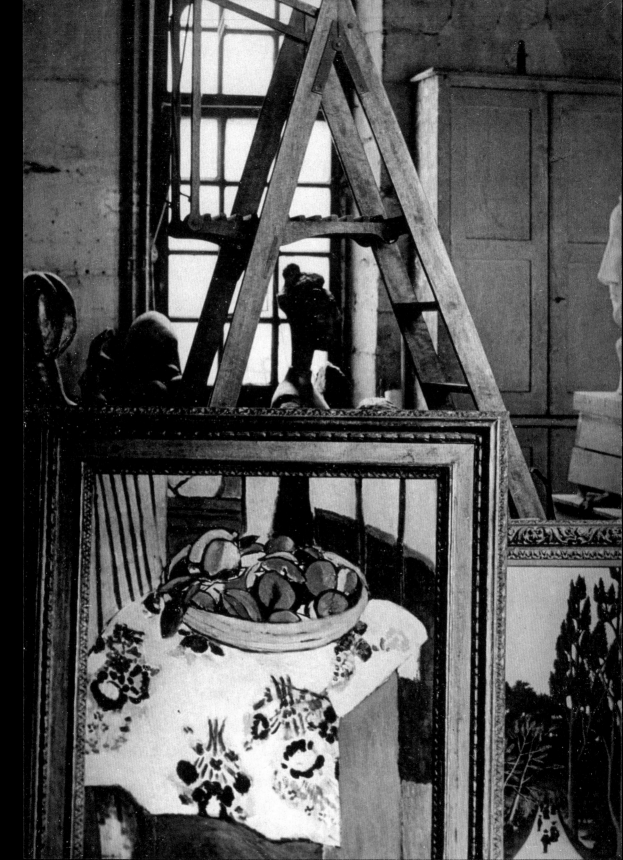

The painting 'born of misery'

On 29 January 1912 at 1pm, the couple's boat docked in Tangier in 'splendid weather'. Soon afterwards it started pouring with rain. And the deluge continued for weeks and weeks. Matisse complained that it was 'impossible to leave the room'. One can imagine the atmosphere in room 38 of the Hotel de France: Amélie simmering and Matisse wretched. Matisse painted a bowl of oranges sitting on a Bohain fabric. In November 1942 this painting was bought by Picasso (who had long since made up with Matisse), who could never understand how such a vibrant painting could be painted in such misery. But is all well? Matisse includes the fruit stalks and leaves, possibly alluding to the wild nature that he went looking for in Morocco and which he failed to find in those first miserable weeks. So nature's bounty had to be picked up at the local market, and sits contained in a bowl. Meanwhile the vertical bars of the striped curtain fabric and the balcony rails emphasize the claustrophobic space of room 38. Matisse wrote home, 'Ah Tangier, Tangier! I wish I had the courage to get the hell out of here.'

'It's so sweet when it comes effortlessly.'
Henri Matisse

Having been absorbed for so long in the study of art, Matisse was desperate to reconnect with the physical world. He had travelled to Morocco in search of a specific type of nature. He'd read Pierre Loti's book *Au Maroc,* in which Loti relishes Morocco's 'dreamy light, and its endless carpet of wild flowers'. In a sense Matisse was hoping for an ornamental landscape that had the quality of an Islamic rug. When the rain finally stopped, he was not disappointed. Matisse describes the transformation: 'there sprang from the ground a marvel of flowering bulbs' and 'All the hills round Tangier, which had been the colour of a lion's skin, were covered with an extraordinary green.' He sketches himself painting outdoors in a suit, sweltering in the heat for the sake of playing the smart, respectable European.

Photograph of
Basket with Oranges
(Nature morte aux oranges)
Photography by Brassaï, 1943

Henri Matisse, 1912
Oil on canvas
94 x 83 cm (37 x 32½ in)
Musée du Louvre, Paris

Room 38
became a family joke:
bad times were 'room 38' experiences.

Morocco's floral carpet

Matisse and Amélie joined a trek to the village of Tetuan, and Matisse recounts: 'We rode in among this sea of flowers as if no human being had ever set foot there.'

Reaching up to the mules' saddles, wild buttercups and daisies radiated their warm yellow hue. Having found confirmation for his bright palette in the Byzantine and Oriental tradition, now the sweet landscape of Morocco – its floral carpet – shined forth the same pure, radiant colour. Matisse would later explain,

> Flowers provide me with the chromatic impressions that remain indelibly branded on my retina, as by a red-hot iron. So, the day I find myself, palette in hand, in front of a composition and I know only very approximately what colour to use first, that memory may suddenly spring within me and help me, give me an impulsion.

A heavenly light

The sombre skies of Bohain had motivated Matisse to seek out the light of the south. He'd experienced the ferocious, blinding light of Corsica, and Biskra, which inspired his raging Fauve palette, but Moroccan light is very different. It has an exquisite softness. Matisse spoke of the 'deliciously delicate mellow light'. Unlike the scientific outlook of the Impressionist painter of the previous century who systematically recorded precise times of the day, Matisse was focused on the unfathomable, and glorious, moments of nature.

The party had set out at dawn so they would have experienced the magic of 'golden hour' – that transient moment of the day that cinematographers chase, when the light is unspeakably beautiful. Matisse discovered the sacred in the real world. Art historian Pierre Schneider describes the light as 'abstract'. But this dawn light is utterly real and its radiance and depth, 'warms the cockles'. Matisse bathed it in. An earthly paradise, the landscape had the golden atmosphere of the Kremlin chapel.

A heavenly message in earthly terms

In Tangier, Matisse was invited to paint in the grounds of Villa Brooks and was inspired by their endless meadows and wild vegetation: 'My spirit was exalted by these great trees, very tall and below, the rich acanthus… provided a… sumptuousness.' He later told Alfred Barr, one of his collectors, that he conceived *Palm Leaf, Tangier* (1912) in 'a burst of spontaneous creation – like a flame – in the *élan*'. Echoing the energy of the *Blue Nude* – and the wild dancers from *Dance*, nature now releases its force. The spiky leaves of the palm form an explosive core which radiates energy.

In his correspondence dating from the trip, Matisse mentions that he is reading Bergson's philosophy every day. We don't know which particular text, but in his comment to Barr, Matisse references Bergson's *élan vital*, that surging life force Bergson defines in *Creative Evolution*. The impulse of the *élan vital* is to generate new life, and 'the creation of forms, the continual elaboration of the absolutely new'. In the radiating core of *Palm* Matisse synchronizes nature's creative force with the creative process of painting. Leaving areas of blank white canvas showing through, he creates a brilliant dazzle. As if ignited, 'creation occurs', and nature bursts forth in new forms.

Morocco's floral landscape left a deep impression, but its 'revelation' would manifest more in Matisse's final years, when flowers populated everything from letters to a monumental cut-out. There is earlier manifestation in his design for the Mandarin's costume for a Ballet Russes production (see page 56): the lush golden silk and the simple flower motifs resonate that trek through fields of yellow flowers at dawn.

Counter to the blissful nature was the volatile political situation: colonial expansion had created resentment and there were constant violent revolts. On this first trip Matisse had not been able to visit Fez as it was under siege. He set sail to France and a few days later a major revolt broke out, in which many French colonials were massacred. After a few months of being home, Matisse decided to take a second trip to Morocco.

Palm Leaf, Tangier (Le Palmier)
Henri Matisse, 1912

Oil on canvas, 117.5 x 81.9 cm (46¼ x 32¼ in)
National Gallery of Art, Washington DC
Chester Dale Fund (1978.73.1)

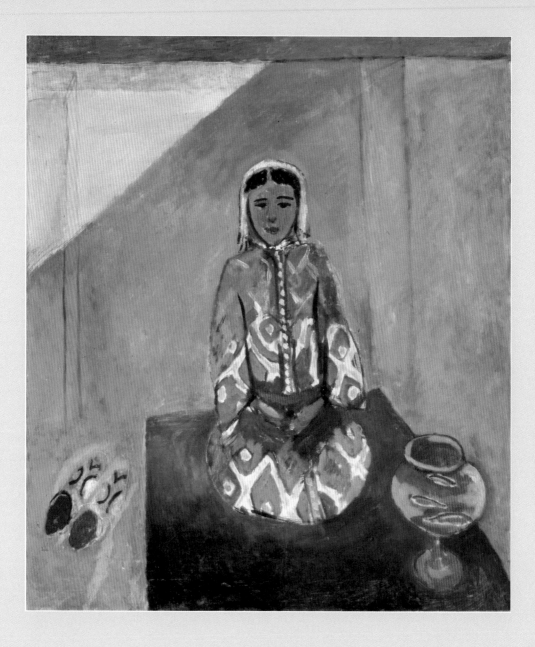

On the Terrace (Sur la terrace)

Henri Matisse, 1912-13

Oil on canvas
115 x 100 cm (45¼ x 39⅜ in)
The Pushkin Museum of Fine Arts, Moscow

A greater simplicity

Matisse wanted to paint people again. In Morocco, it was difficult to find models since Islamic faith forbids images of the human form. On his first trip he'd painted a young prostitute called Zorah. Matisse found her brothel and she posed for him on the rooftop between clients. As Matisse could not compete with the prices Zorah received from her clients, he bribed her with French biscuits. The sittings were fraught, as Matisse was aware that if Zorah's brother found out that she was being painted, 'he would kill her'.

In spite of the anxious situation, calmness infuses Matisse's portrait of Zorah. In contrast to the ferocious Fauve palette, the tender blues and greens that Matisse would always associate with Morocco play against each other. There is no conflict between figure and formal arrangement. The brittleness of his family portrait dissolves. Zorah inhabits a spiritual space. The slippers to the side of the rug have been removed before entering, reflecting the Islamic custom of leaving shoes at the door of the mosque. Sitting on an Islamic rug, upright in the position of prayer, Zorah has the grandeur and tranquillity of the figures in Russian icons.

Face to face

In his diary, Marcel Sembat summed up a visit to Issy in 1913: 'Saturday with Matisse. Crazy! Weeping! By night he recites the Lord's Prayer. By day he quarrels with his wife.' In the autumn Matisse painted Amélie for the last time. It turned out to be a long, arduous process that involved more than 100 sittings. In the early stages, Amélie had a delicate beauty, but as the portrait progressed, her image became more and more austere. In the final portrait we meet Amélie, dressed in a business suit, her face and body ash grey, and with black hollowed eyes that have no capacity to look or absorb the world around her. The only characterful element is her fancy hat with its small flower and ostrich feather. When Amélie saw the painting, she cried.

Picasso and Matisse had now become friends, and during the evolution of this portrait, Picasso visited Matisse many times in his studio. The portrait acknowledges Picasso's recent experiment in Cubism – the reduced palette and geometric form is essentially Cubist language. The severe style suited his estranged wife; in this respect his later rejection of Cubism has bearing on this attitude to his wife at this point: 'Of course Cubism interested me, but it did not speak directly to my deeply sensuous nature.' To continue creating rich, sensuous art, Matisse would rely on models.

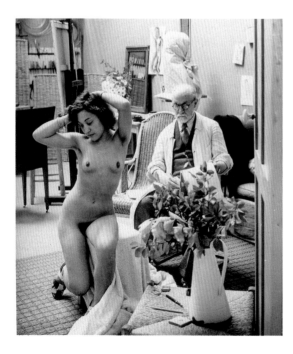

Photograph by Brassaï
Matisse drawing the model
Wilma Javor at the Villa Alésia
studio, Paris, Summer 1939
Gelatin print,
9.8 x 6.8 cm (3⅞ x 2¾ in)
Private collection

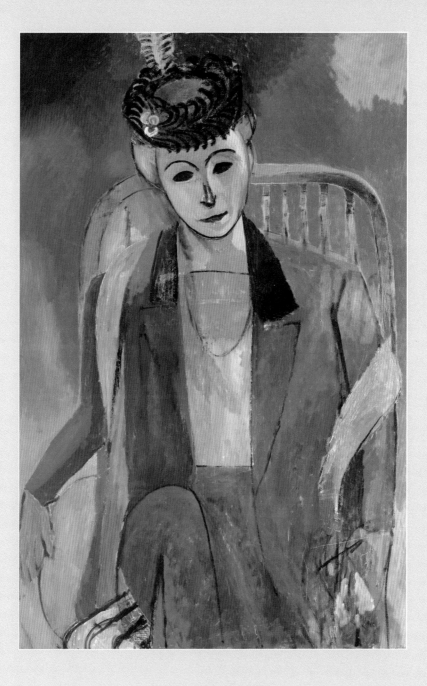

Portrait of the Artist's Wife
(*La femme de l'artiste*)
Henri Matisse, 1913

Oil on canvas, 146 x 97.7 cm (57½ x 38 in)
The State Hermitage Museum, St Petersburg

The line portraits

As Europe was accelerating towards war, Matisse and Prichard started working together on a series of portraits. Prichard would secure the commissions and prepare sitters for a new radical approach, while also gathering fellow Bergson enthusiasts to witness their creation: 'Today we, Camille, Schiff, the Tylers, and I go to Matisse's to see the beginning of the Landsberg portrait.'

When Matisse met Yvonne Landsberg, he was fascinated by her youthfulness and identified her with a magnolia flower that was in his studio. In the etching, Yvonne's head, with its hair flat against the scalp, is like a tight, unopened bud. While her elongated neck pushes forward, like a young stem emerging from the ground, the bud of youth waits to flower like the blossoming magnolias around her.

The portrait experiment seems to have been prompted by Prichard reading Henri Bergson's earlier psychological text, *Matter and Memory*. In this respect Yvonne was the perfect sitter: her brother later recalled that 'When this great portrait or poem was painted, the model together with Prichard and myself, used to attend Bergson's famous and unforgettable lectures at the École de France'. Prichard had a clear position on portraiture. He insisted that an artist should not concern himself with the appearance of his sitter; 'It is wrong, therefore, to consider expression at all in terms of likeness.' Instead he identified a person's character with their inner *durée* – that fluid, internal time. From his portraits, Matisse would seem to be in agreement. He describes his struggle to capture one sitter's inner rhythm, then finally, 'It was a miracle. She is a flowing stream'. This is portrait painting as invocation.

Landsberg moved with great rhythm, naturally suggesting the flow of *durée*. But how was Matisse to convey this inner flowing time? Prichard talked of the impulse of his line: 'The line-part of a Matisse [that is] the indication to action.' Already we have seen his dynamic line work: the thick circulating outline in *Dance* has real energy, as do his arabesques. During the experiment Matisse pares everything back, and focuses on drawing and etching, where line stands alone, isolated from colour. In the etching of Yvonne, some of the lines have real fluidity, such as the shimmering lines of her hair, the open circular lines round her shoulders, and that arching line of the neck. However, the expression of action is limited. Matisse is still bound by the tradition of representation, and conveying a likeness.

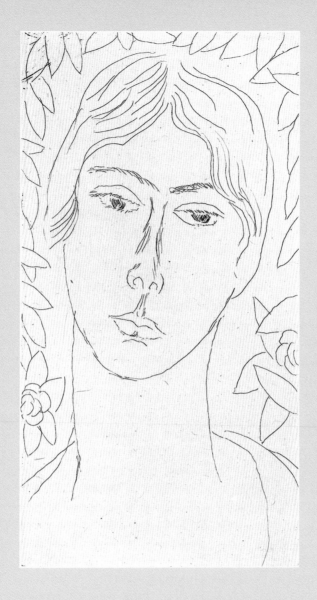

Mlle Landsberg (Grand planche)
Henri Matisse, 1914

Etching, 20 x 11 cm (7⅞ x 4⁵⁄₁₆ in)
The Museum of Modern Art, New York
Gift of Mr & Mrs E Powis Jones

A wartime austerity, 1914–1918

During World War I, trenches carved up the flatland of northeastern France where Matisse had grown up. His homeland became a mud pit where millions of soldiers died. Matisse tried to enlist but was refused on the grounds that at 45 he was too old. The war years were fraught; his mother was living in Bohain, which was blitzed by bombs, most of his young friends had joined up and his greatest supporter, Matthew Prichard, was interned in a German prison camp: Matisse and Amélie sent parcels of food and letters of encouragement to him. In the final years of the war his sons joined up; Matisse met his son Jean, who was in an appalling state, on leave and sent him back with a warm coat and sweater. During the war Matisse spent more time with Picasso and a dialogue develops in their art: Matisse continued to explore Cubist ideas while Picasso looked at Matisse's vibrant colour.

The Ballet Russes, 1919

Shortly after the Armistice was signed in November 1918, the Ballet Russes director Serge Diaghilev and the legendary composer Igor Stravinsky visited Matisse at his home in Issy-les-Moulineaux. Stravinsky sat at the family piano and played the music for *Le Chant du Rossignol*. Their hope was to convince Matisse to work on the stage designs and costumes for the ballet.

Such a commission offered Matisse the possibility of extending the ideas that he was exploring in his art to the stage. In effect the dancers pictured in *Dance* were now real dancers, moving in real space and time, performing in front of a live audience.

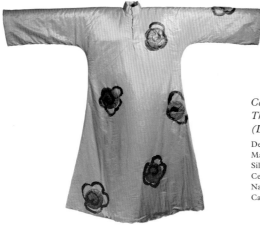

Costume for a Mandarin,
The Song of the Nightingale
(Le chant du Rossigna)

Designed by Henri Matisse, c.1920
Made by Marie Muelle
Silk, cotton, lamé, ink, Bakelite
Centre back 114 cm (45 in)
National Gallery of Australia,
Canberra

Le Chant du Rossignol, 1917

The collaboration proved unsatisfying and Matisse struggled to realize his vision. There were a few successes. The Mandarin costume, with its golden colour field and dark graphic flowers, has the purity of Matisse's late art.

The project gave Matisse the opportunity to work with fabric, which resonated with his family history of weaving. Dismayed by the first choice of fabric for the Emperor's costume, Matisse searched for something better and found an exquisite, very costly red silk velvet. Matisse worked directly with avant-garde dress designer Paul Poiret. Irritated by Poiret's couture team (who estimated that it would take three months to complete the costume), Matisse took charge. Laying the new fabric across Poiret's cutting table, he took his shoes off, seized a pair of dressmaker's scissors and jumped up onto the table. He found the scissors 'as sensitive as pencil, pen or charcoal, maybe even more sensitive'. Cutting into some golden fabric, he created his first cut-outs; the golden motifs were pinned onto the red velvet by Poiret's assistants. His later, much-celebrated cut-outs would be made in the same way, by cutting into pure colour.

'Everything is fake, absurd, amazing, delicious.'
Henri Matisse

From 1917 Matisse lived mostly alone in Nice. His excuse was the incredible light there: 'I'm from the North. When I realized that every morning I would see this light again, I couldn't believe my luck.' But Nice was also an escape; to quote the artist, 'Yes I needed to be able to breathe… forgetting my cares, far away from Paris.' Amélie stayed in Paris. They now preferred living at a distance.

The French Riviera had become a destination for pleasure seekers: American author Scott Fitzgerald and his wife Zelda, Isadora Duncan and Hollywood film director Rex Ingram decamped there after the war. French film director Jean Vigo was deeply cynical 'of a society so lost in escapism that it sickens you'. His film *A Propos de Nice* (1930) satirizes the city, and the empty frivolity; one sequence shows an elegant woman sitting on Promenade des Anglais while different outfits are transposed on to her, and finally she is stark naked – she remains completely unaware and disconnected.

Matisse attended a few parties, but mainly cocooned himself away; in a letter to Amélie he describes himself as the 'hermit of the Promenade des Anglais'. He kept a military routine, rose at 6am, exercised, worked and rested. But he was distracted. For the first couple of years he lived in hotels – cheap rooms with nondescript French furnishings, a far cry from the decorative order of Issy-les-Moulineaux. Although he considered himself a 'foreigner' in Nice, he absorbed its atmosphere. In fact the Vigo sequence touches on the character of Matisse's Nice period; his paintings of odalisques show beautiful, passive women, who are marched through endless costume changes.

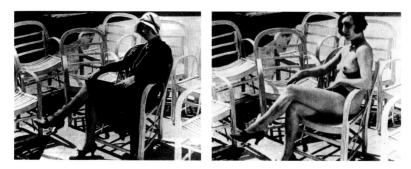

Stills from A Propos de Nice
Jean Vigo, 1930

Little Hollywood

Up until this point, the core of Matisse seems to be his sincerity,
but in Nice he was attracted to the city's 'fake', 'absurd',
'amazing', 'delicious' character. He was lured by the glamour of
the infant film industry, which would rapidly expand in the 1920s
with Rex Ingram setting up studios there. A regular cinema-
goer, he visited the film studios, once staying late to watch a
shoot, apparently fascinated by the camera lights. His apartment
was more like a film set than a home. He hired a local carpenter
to construct a folding screen from an African hanging, which
he used as a backdrop for his paintings. He recruited models
from film sets; his principal model Henriette Darricarrère had
trained as a ballet dancer before she worked as an actress and
film extra. Matisse's rich collection of textiles would become
her stage wardrobe; for seven years Henriette would act out
Matisse's oriental fantasy.

The Sultan of the Riviera

Matisse's Nice period has a conservatism that is matched in the work of other artists in the same period. His art takes a more recognizable Western form, playing to Western traditions of representation. Matisse talks about his art having 'corporeality and spatial depth, the richness of detail'. Essentially, the solid world that he dissolved in *Red Studio* is boldly reasserted. Things have substance. Spaces are marked out. The body is given weight. The women are quite fleshy, in fact. And the impulse of decorative patterns is held back. To quote Schneider: 'Now the floral repetitions... the reiterated arabesques and geometric figures retreated into the object from which they originated, the rug.'

Condemned by most critics, the work points to a traumatized post-war Europe, a society trying to distract itself from a painful history. Matisse immerses us in the heady pleasure of the Riviera. His fanciful *Odalisques* series earned him the title 'The Sultan of the Riviera'. Almost all the works are harem-like scenarios; voluptuous odalisques laze in chairs, or spread out on the divans. Bejewelled, nude or semi-nude, they seem indifferent to the rich spoils that surround them. Their apathy provides a stark contrast to Matisse's *Blue Nude*, or indeed the forceful revellers from *Dance*.

A few odalisques overcome their ennui. Matisse specialist Jack Flam picks out the 'breathtaking eroticism' of *Odalisque with Magnolias*. Although lying down, the woman engages with us, her heavy eyes look at us. The abundant flowers and fruit act as symbols of her sexuality. While the violet-hued flowers suggest the perfumed sweetness of her flesh, the heavy magnolia heads bend suggestively towards her body.

But Matisse tired of these theatrical scenes. And he was acutely aware of how they were being received; when artist Georges Braque visited him in his studio, he winced at the work and tried to avoid looking at it. In 1928 Matisse wrote to his wife, and described the need 'to extricate [himself] from the odalisques'. As had often been the case, a decision to travel was the answer, this time the South Seas via the Americas. He set sail for New York on 25 February 1930.

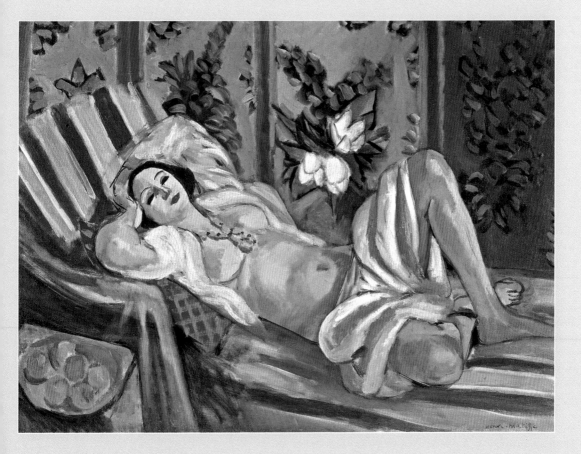

Odalisque with Magnolias
(Odalisque avec magnolias)
Henri Matisse, 1923-24

Oil on canvas, 65 x 81 cm (25⅝ x 31⅞ in)
Private Collection

New York

Years later, Matisse would recall:

> The first time that I saw America, I mean New York,
> at 7 o'clock in the evening, this gold and black block in the
> night, reflected in the water, I was in complete ecstasy.
> Someone near me on the boat said: 'it's a spangled dress',
> which helped me to arrive at my own image. New York
> seemed to me like a golden nugget.

Energized by the city, he loved how New Yorkers embraced
risk and would tear down the old to reconstruct their cityscape.
Perhaps he was reflecting on Bohain, which, after being blitzed
by bombs, had struggled to reinvent itself. He liked New York's
grid layout and the wide streets, which he felt brought clarity
to everyday life, saying: 'you can think very comfortably in a
New York street.'

But most of all he was struck by the Manhattan skyscrapers.
Tapered as they rise, Matisse observed,

> The skyscraper gives us the sensation of a gradation of tones
> from the base to top. The gradation of tone which evaporates
> in the sky… gives the passer-by a feeling of lightness which
> is completely unexpected by the European visitor.

Matisse had experienced this feeling of feather-lightness before
in the architecture of the Alhambra; at this point he identifies how
it corresponds to a feeling of release, of exultation.

Matisse hadn't expected much from New York. Now reluctant to
leave, he headed to San Francisco, where he boarded the RMS
Tahiti, a worn out, retired mail boat. The trip was a punishing ten
days: the captain was wretched, and squashed amongst New
Zealand sheep farmers, Matisse felt seasick.

Tahiti

Since the 1890s, Tahiti had been associated with Paul Gauguin, who had created his last masterpieces on the island and died there in 1903. Like Gauguin, Matisse identified Tahiti with an idyllic order, a golden age. Gauguin had been more interested in the culture (and saw Tahitian society as an untainted, primal civilization), while Matisse's Tahiti was an Eden, an unspoilt Nature. Back home, Matisse remembered the different calls of the wild birds, the swishing of palm leaves in the wind, and the golden atmosphere scented with the musky aroma of coconuts, and the sweet smell of vanilla.

Unlike the monotony of the crop fields of his childhood, Tahiti had a truly bio-diverse landscape. Matisse studied the plant forms in meticulous detail; on one trip, he jumped out of the car and sat by the road, and fanned a plant, just to see how it moved in the wind. With great lavish, he describes Tahiti's majestic trees:

> Trees… you can't imagine what the trees are like! The ones here form a ponderous nave weighed down with rain, with night, with eternity, dripping its dampness onto the earth… You see leaves waving like big hands in the mass of the foliage, and fruits pendulous as moons.

Above all, Matisse was struck by the island's incredible light. He talked of the intense midday light – how it cast ink-blot shadows on the ground – and while he was there he photographed the effect. His later cut-outs have the flatness of these ink-blot shadows. And he found the rich, sumptuous tones of the golden hour even more beautiful than Morocco's: 'The light of the Pacific, of the islands, is a deep golden goblet which you look at.'

Memories of South Seas

Matisse's experience in the South Seas was very different to the Moroccan encounter. In Morocco, he seemed very much a stranger in an alien world. In Tahiti he was chaperoned by Pauline and Etienne Schyle, who made the whole experience very comfortable for him. And although he despised the colonial white culture, he did discover like-minded people. Avant-garde filmmakers Friedrich Murnau and Robert Flaherty were shooting the film *Tabu* (1931) at the time of his visit, and for a week Matisse joined them on location in their reed huts on Tahiti's deserted coastland. Murnau photographed him sitting in the bow of a palm tree, writing.

The highlight of Matisse's trip was the four days he spent on the island of Fakarava, diving in the coral reefs. The now 61-year-old artist tells how he moved 'with an indescribable virile voluptuousness'. In a sense, he experienced the sensuous pleasure that he strove to capture in his art. In the water, he experienced two realities merging:

> Two landscapes seen simultaneously: one above the water where palm trees and birds stood out sharply, the other in the underwater brightness with madrepora, pink and purple corals.

On his return, Matisse would start work on the Barnes frieze, which would cause him endless problems. Also Amélie, who had joined him in Nice, was miserable, racked with pain and bedridden; Matisse struggled to look after her and complained to friends that, 'I came back from the islands with empty hands'. However, he had rich memories: the feeling of swimming in the lagoon, of being weightless in the water, and moving effortlessly. These vivid memories lay dormant for almost fifteen years, but burst forth with a new, lyrical energy in the 1940s.

Polynesia, The Sea – painted after the couple separated – is an example of the eventual release of memory: the deep blue of the sky and sea, the white coral reef and the fantastic birds and fish. And all of the images have that flatness of Tahiti's inkblot shadows. For years Matisse had struggled to create art, but it came effortlessly when he drew on his memories of Tahiti. Weightless, the birds and fish move with 'indescribable virile voluptuousness'.

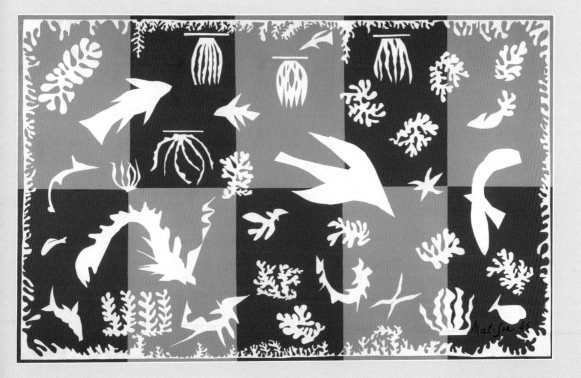

Polynesia, The Sea (Polynésie, la mer)
Henri Matisse, 1946

Gouache, remount, glued papers, 196 x 314 cm (77 x 123⅜ in)
Musée d'Art Moderne, Centre Pompidou, Paris

The Barnes project

In 1930 the American art collector Alfred Barnes commissioned from Matisse a mural-like painting to fit into three alcoves of his sitting room in Merion, Pennsylvania. It was always going to be a tricky project: the three alcoves were awkwardly shaped and their orientation made viewing almost impossible. And Barnes was a difficult customer to please. Having almost completed the work, Matisse realized that the dimensions were wrong and was forced to start again from scratch.

Despite the false start, we find Matisse back on form. Released from the heady inertia of the *Odalisques*, he depicts a world in motion. The Dionysian energy of *Dance* of 1910 runs through the frieze, although the atmosphere is somehow lighter. Steely grey and weightless, the dancers move freely in space. Matisse explained to the Russian art critic Alexander Romm that he wanted 'to enclose… the spectator in a feeling of release'. This echoes his impression of the New York skyscrapers which he had described in the very same terms.

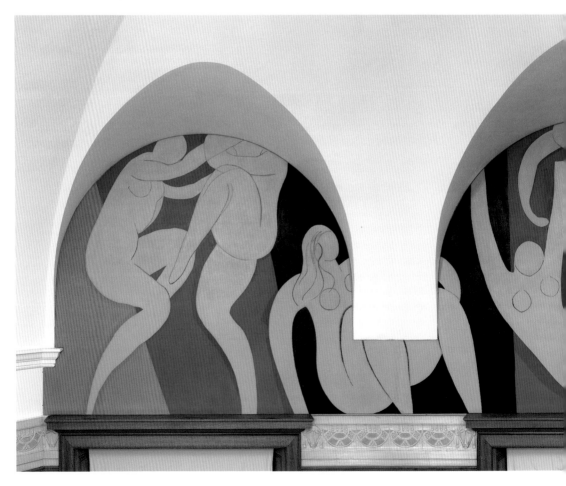

Matisse did many sketches before starting work on the frieze. Picking up the drawing experiment with Prichard, he went back to his childhood antics – and playing the mimic, Matisse internalized the dance, the trajectory of his line following the movement as it unfolded. When Matisse started painting, he became frustrated, unable to express the same fluidity. He abandoned painting and went back to the 'cut-out' method used in his designs for the ballet. His assistant prepared stacks of rose, blue and grey coloured paper, and, like a tailor, he picked up his scissors and cut out the designs. The steely precision of the cut-out line directs the dynamic impulse.

Matisse didn't use the cut-out method again until 1943; in the period 1930–1943 he focused almost exclusively on drawing, creating works with a startling graphic purity, often with a single black line set against white space. In such taut simplicity, again there seemed no place for colour, which came to bother Matisse. He wrote to a friend, 'My drawing and my painting are completely separate from each other.' Once again the cut-out would offer a solution.

The Dance (La danse)
Henri Matisse, 1932-33

Oil on canvas; three panels;
Left: 339.7 x 441.3 cm
(133¾ x 173¾ in)
Centre: 355.9 x 503.2 cm
(140⅛ x 198⅛ in.)
Right: 338.8 x 439.4 cm
(133⅜ x 173 in.)
The Barnes Foundation, Philadelphia

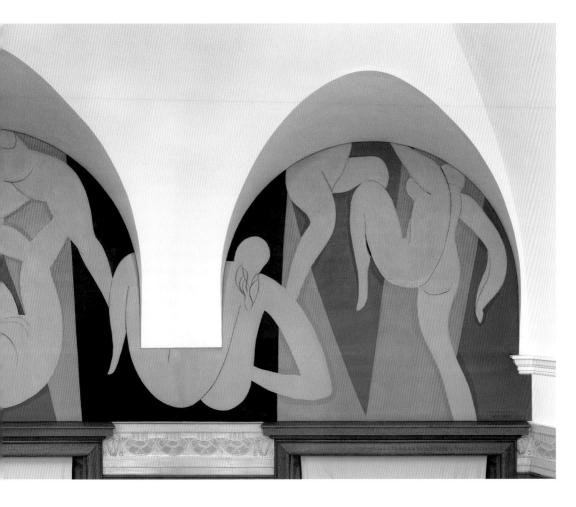

The end of a marriage

Lydia Delectorskaya – a Russian émigré – started work as Amélie's nurse. Over time, she became Matisse's model, secretary and studio assistant. Amélie became very jealous of her. Things came to a head when Amélie insisted that Lydia was let go and Matisse refused. He was furious that his wife would imply that his relationship with Lydia was inappropriate. Galvanized by the drama of the situation, a friend reports, 'Mme Matisse, after remaining bedridden for the last twenty years, suddenly rose up'. Amélie left Nice for Paris. Matisse was to hear that his wife – an invalid for so long – was seen running down a Parisian boulevard to catch a bus. It was the end of a 41-year marriage.

Hilary Spurling argues that Amélie was angry that Lydia had taken her role as Matisse's protector and organizer. Her jealousy was probably more basic. In 1936 *Cahiers d'Art* published a book of Matisse's latest drawings, most of them of Lydia. Perhaps Amélie was reacting to her husband's very public infidelity, revealed in the blatantly erotic studies of a 24-year-old woman. In his words, he drew as 'a means of expressing intimate feelings'. Sublimating his desire, his line traces the contours of her body. Expressing a need to be close, he appears in some of the images, once reflected in the mirror sitting beside Lydia, in another he shows his hand drawing the image. The couple always denied that they were sexually involved. Lydia kept a suitcase packed in the cupboard, ready to leave at any point.

Reclining Nude in the Studio (Nu couche)
Henri Matisse, 1935

Pen and ink on paper, Cahiers d'Art, 1936
Special edition devoted to Matisse

Another war

With the Nazis occupying the northern half of France, and the South under a French puppet government, Matisse had an operation to remove a cancer. He recovered, though his stomach muscles were badly damaged. During his convalescence, art critic Pierre Courthion met up with him. The artist was restless; Courthion noted that 'As he talks, Matisse draws on the tablecloth with his nail, then, driven by some inner need for continuity, tries to line up the stripes on its hem.' Anxious that he had not yet realized his vision, a sense of urgency overtook him. While he re-examined early influences (during a bombing raid he reread Bergson), memories of Tahiti and Morocco played in his mind.

The bombs continued, and Amélie and Matisse's daughter Marguerite, who had been working for the Resistance, were in danger. On 13 April 1944, Matisse wrote to a friend, 'I've just had the worst shock of my life': Marguerite had been arrested by the Gestapo and Amélie was captured the same day. Amélie was imprisoned for six months and Marguerite, after being tortured, was put on a train destined for a German concentration camp. By chance the train stopped, the gates of her carriage opened, and she escaped and hid in nearby woods. At home, everyone thought that she would be broken by her ordeal, but friends discovered a radiant Marguerite. With the same tenacity, Matisse overcame his health problems; later he would say that his illness prompted his best work. The cut-out is central to this.

Revelation of the cut-out

In 1943 Matisse focussed on his cut-outs. In a photograph of him making one, mid-performance, with dramatic light-and-shadow effects, the artist emerges like a bright flame from the dark background, transfixed by his own creation in the process of its evolution. The creative process becomes fundamental to the meaning of his work. Among Matisse's old friends was the Surrealist artist André Masson, and the immediate, unpremeditated nature of the cut-outs have parallels with the Surrealist automatic drawings. However, while the Surrealist drawings are a mesh of lines with hidden images, there is always a remarkable unity to Matisse's work. In Matisse's hands the image is determined in the process. Like peeling an apple in one, the emergence of the image seems magical. Matisse felt that God directed him; he was there simply to release the images:

> 'Do I believe in God? Yes, when I work. When I am submissive and modest, I sense myself helped immensely by someone who makes me do things by which I surpass myself. Still I feel no gratitude towards *Him,* because it is as if I were watching a conjurer whose tricks I cannot see through. I then find myself thwarted of the profit of the experience that should be the reward for my effort. I am ungrateful without remorse.'

Matisse cutting paper in bed at his home in Vence in 1947.

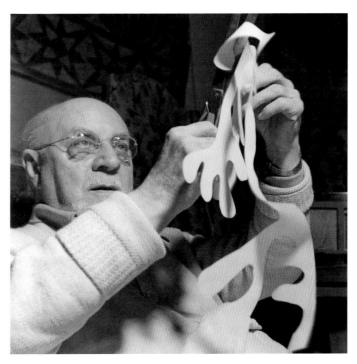

Recollections

The cut-outs are joyful. Colour and line are in harmony; Matisse explained: 'I "draw" directly with the colour, which… guarantees a precision in the union of the two methods.' They are a celebration of Matisse's life gems cut from his past. *The Sword-Swallower* is likely a memory of Pinder's travelling circus which visited Bohain every year, and enlivened the dreary village life of Mattise's childhood. The image vibrates with the colours of the circus. Isolating the head of the sword swallower suggests the perspective of a child, transfixed on the spectacle and unaware of anything else around him.

In other cut-outs, the flowers of Morocco are enlarged. But it is really Tahiti that preoccupies Matisse. Matisse had stayed in contact with his Tahiti guide, Pauline Schyle. She sent him vanilla pods and banana chips; their smells probably kept Tahiti alive for him. Prompted by an accident, Matisse came to infuse his home with flavours of Tahiti. Having cut out a swallow, Matisse had the idea of pinning it to the wall to hide a dirty stain. The bird must have appeared as if it was soaring into the sky, and the crisp, white form worked well against the golden wallpaper. Perhaps the wallpaper's warm, rich tone reminded him of Tahiti's golden light, and the musky sweetness of the vanilla plant that grew so abundantly on the island. Matisse went on and added more birds and Lydia shifted them around until he was happy. By the end, he transformed the wall into a Tahiti sky, animated with circling birds. On the adjoining wall, he would recreate Tahiti's sea. In his old age, and in the comfort of his home, Matisse immersed himself in the South Seas.

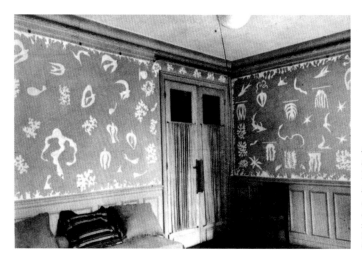

Matisse's studio on the boulevard du Montparnasse, Paris
Photograph by Hélène Adant, 1946

On the walls, left: an early state of *Polynesia, the Sky*; right: *Polynesia, the Sea*. Bibliotheque Kandinsky, MNAC, Centre Pompidou, Paris

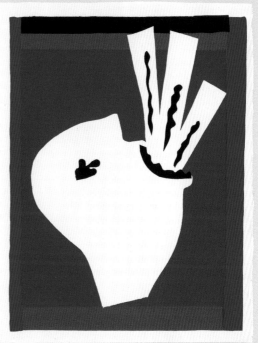

l'esprit humain.
l'artiste doit
apporter toute
son énergie,
sa sincérité
et la modestie
la plus grande
pour écarter
pendant son
travail les
vieux clichés

90

The Sword Swallower, from Jazz
(L'Avaleur de sabres)
Henri Matisse, 1947

Jazz published by E. Tériade
42.2 x 65.1 cm (16⅝ x 25⅝ in)
The Museum of Modern Art, New York
The Louis E Stern Collection

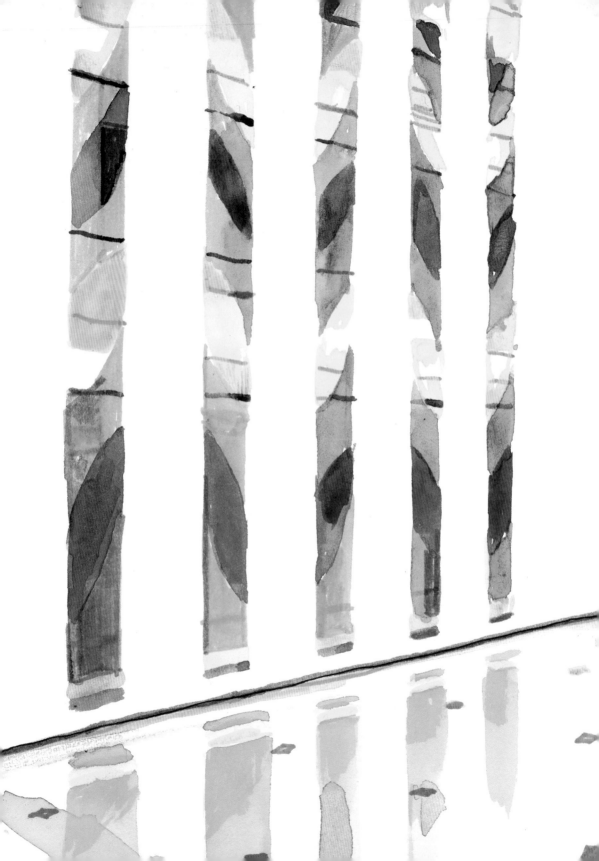

CHAPELLE DU ROSAIRE IN VENCE
'The crowning achievement of my entire life.'

At 77 years old, Matisse started the most ambitious project of his life. Collaborating with an architect, he masterminded the design of the chapel and created the intricate decorative scheme, which combines stained-glass windows, painting on tiles, textiles and exquisite metalwork.

Matisse believed that God directed him. Echoing the Kremlin cathedrals, the chapel offers an intimate encounter. Warm tones resonate, while other memories play out. Of the soaring stained-glass windows, Matisse tells us 'That's a breadfruit tree'.

Matisse endlessly searched for coloured glass that would cast blood red and iridescent blue reflections across the floor. And the blue had to be the one 'seen before in the sheen of butterfly wings or the flame of burning sulphur'.

A final dance

On completing the chapel Matisse said, 'My bags are packed'. The project had exhausted him. His eyes were excruciatingly painful, he was having breathing problems, and his heart was causing him trouble. Father Couturier describes him as being in a tearful state, with his father very present in his mind. Lydia was also worn out, her packed suitcase still in the cupboard. Matisse refused to slow down, he would continue to experiment and push the boundaries of art. In the summer of 1952 he started on a radical decorative scheme for the dining room and hallway in his home in Regina.

Women with Monkeys was made for the space above the doorway that led from the dining room into the hallway. The almost comic-book simplicity of the stark blue motifs set across the frieze is beguiling. Leo Tolstoy's confrontational essay 'What is Art', published in 1898, attacks the tendency in art and in culture more generally to veer towards the complicated and the theoretical at the expense of being popular and indeed human. For Tolstoy, artistic activity was about being 'infected by… feelings'. This late cut-out undeniably has an infectious quality. Matisse creates resonant signs that magically convey feelings and memories – the sensuous blue is impregnated with the blue of the sea, the butterfly Matisse bought in Paris and that sparkling blue flame that he had burned in his toy museum. The wonderful arching forms of the subjects convey the timeless pleasure of seeing things in movement.

Women with Monkeys
(*Femmes et singes*)
Henri Matisse, 1952
Gouache on paper, cut and pasted, and charcoal on
white paper, 71.7 x 286.2 cm (30⅝ x 112¾ in)
Museum Ludwig, Cologne, Sammlung Ludwig

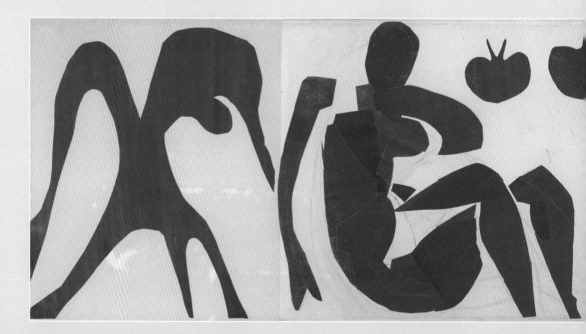

An orchestration of energies, while the voluptuous nudes rest, their outer arms link up with very mobile monkeys, who radiate energy. The monkey on the left unfurls and then curves into a spiralling motion. The innovation is the long frieze structure, which, like a narrative sentence, draws the viewer into its development as it unfolds in time and space. The frieze form had always intrigued Matisse. The regularly placed figures create a rhythm through which energy flows, like musical beats. In their original setting in Matisse's home, the fluid blue energy continued around the dining room with *The Swimming Pool* friezes unleashing a powerful, ritualistic water dance, while *Blue Acrobats* spiralled down the hallway. Prichard's very early description of Matisse's art encapsulates the spirit of these final works:

> Matisse paintings are not to be considered for what they are, not as things, but as energies, adjectival, substantial and verbal. As action they do not present us with action accomplished but are incentives to us to effect action. They represent nothing but impel us to create in the direction of the force, which they exercise.

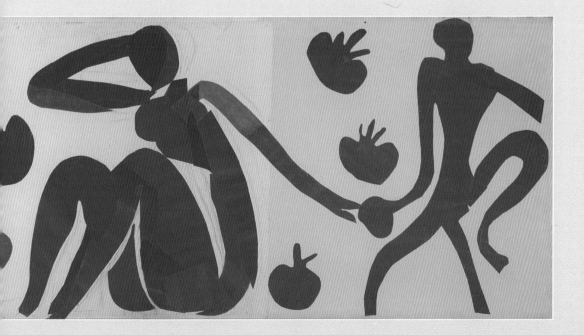

'**And I promised myself… that when my time came,
I would not be a coward.**'
Henri Matisse

Artists who peak in their youth often experience a miserable
decline. Matisse's brush with death focused him: 'Truly, I'm
not joking when I thank my lucky stars for the awful operation
I had, since it has made me young again and philosophical,
which means that I don't want to fritter away the new lease of life
I've been given.' With his home filled with the exquisite souvenirs
that he collected from all over the world, and aided by his
beautiful companion Lydia, he created his most radiant art.
When Picasso visited Matisse towards the end of his life, he left
feeling perplexed, jealous, still deeply competitive with the
bedridden Matisse.

Matisse's late work had an unprecedented playfulness, an
extraordinary lightness. Modern writer Italo Calvino speaks
of the virtue of the feather-light and the 'flight into a realm where
every need is magically fulfilled'.

For Matisse 'work cures everything', and he worked to the end of
his life. The day before he died, he noticed Lydia walking across
the room, her hair tied up in a towel, having just taken a shower.
He asked for a pen and paper and sketched her. Looking at his
last piece, he said, 'It will do'.

Matisse is buried in a private garden of the Franciscan monastery
in Cimiez, which overlooks the bay of Nice. Amélie's grave lies
beside his. The day after Matisse died, Lydia took her packed
suitcase from the cupboard and left.

Matisse at his home in Nice
1948 Photograph by Gjon Mili
for LIFE magazine

Acknowledgements

To my dear mum and dad, remembering all of our wonderful holidays in the South of France.

My thanks go to Laurence King for taking on this nutty project in the first place, Angus Hyland for his creative direction and Jo Lightfoot and Donald Dinwiddie for their management of the *This is* series. Thank you, Donald, for your thoughtful editing. I am grateful to Gaynor Sermon, whose sensitive direction and painstaking attention to detail shaped the book into its present form. A big thanks to Alex Coco for his creative synthesis of image and text; his layout enhances the beautiful images. I am very grateful to Julia Ruxton for her careful picture research and for digging out the lovely photo of the smiley Matisse on the final page. An overdue thanks to Felicity Awdry who sourced the paper and covers of the *This is* books, and made it possible to create this beautiful, but affordable, art book. Many thanks to Lewis Laney for his enthusiasm in promoting the books.

It was very exciting collaborating with Agnès Decourchelle. Thank you Agnès for your wonderful images and congratulations on the birth of Éloi, who I am sure will be a fabulous brother to Aymé.

Many people have generously given their advice. I am especially grateful to Georges Matisse, who worked with Julia to achieve the best presentation of the illustrations. I am also extremely grateful to André-Marc Delocque-Fourcaud, grandson of Sergei Shchukin, who advised me on the hang of *Dance* and *Music* in his grandfather's home. Many thanks to Éléonore Peretti at the Maison Matisse, who sent precious archival photography and advised on the layout of the seed factory. I appreciate the help of Hilary Spurling, who kindly put me in touch with Greta Moll's daughter and whose exceptional biography on Matisse was the first to reveal the misery of the Humbert affair. I would also like to thank Rachel Garver (daughter of Greta Moll) for sending me the most wonderful material.

Love to Matt, Lulu and Sam.

Catherine Ingram

Catherine Ingram is a freelance art historian. She obtained a First Class Honours degree at Glasgow University, where she was a Honeyman scholar. After an MA in 19th-century art at the Courtauld Institute of Art, Catherine became a graduate scholar at Trinity College, Oxford. After finishing her D. Phil, she was made a Prize Fellow at Magdalen College, Oxford. Catherine has taught on the MA course at Christie's and lectured at Imperial College, teaching art history to undergraduate scientists. She has also run courses at the Tate Gallery and was a personal assistant at South London Gallery. She lives with her family in London.

Agnès Decourchelle

Agnès Decourchelle is an illustrator who primarily works in pencil and watercolours. She received her Diploma in illustration from École Nationale Supérieure des Arts Décoratifs in Paris in 2001 and an MA in Communication Art and Design from the Royal College of Art in London in 2003. She lives and works in Paris.

Further reading

Courthion, Pierre, ed. *Chatting with Henri Matisse: The Lost 1941 Interview,* Tate Publishing, 2013

Dumas, Anne, ed. Matisse: *His Art and His Textiles, The Fabric of Dreams,* RA, 2004

Flam, Jack D. *Matisse on Art,* Phaidon, 1973

Jarauta, Francisco, Maria del Mar Villafranca Jiménez. *Matisse and the Alhambra 1910-2010 [exhibition], The Alhambra, Palace of Charles V,* Tf Editores, 2010

Labrusse, Rémi. 'Matisse's Second visit to London and his collaboration with the Ballets Russes', Burlington Magazine vol. 139, no. 1134 (Sept 1997), 588–99

Spurling, Hilary. *Matisse: the life,* Penguin, 2009.

Spurling, Hilary. *The Unknown Matisse: a life of Henri Matisse, volume one: 1869-1908,* Hamish Hamilton, 1998

Taylor, Michael, ed. *The Vence Chapel: The archive of a creation,* Skira, 1999